Gary Tanner
2001
ATLANTA
GA

4/30

"We are all prisoners of our childhood"

John Santerineross

John Santerineross

Attis Publishing
586 Devon St.
Kearny, New Jersey
07032
e-mail: attismail@aol.com

ISBN 0-9673543-0-7

John Santerineross

Fruit of the secret god

Words by Victoria Rimerman

Attis Publishing

Bethalynne Bajema

Foreword

I was asked to do the foreword for John's first book; in the end I found this to be incredibly hard. What could I possibly say that had not already been eloquently stated? The greatest compliment I could ever give to anyone is to say that they move me to write. John's images move me to write.

And it can be said, that what I found was a configuration meant for a creature so much greater then myself. Like the toy maker's puzzle box, created with loving care and burning ambition, only to become the ever shifting paradigm whose solution is known to only the creator himself.

I looked past the configuration into the heart of the room itself. In ignorance and utter apathy I left the mystery to someone else, someone who might be crippled by the desire to see what lay at its heart. For me, there was only one thing that seemed to matter. And that was to move beyond the barrier so I could look into her eyes.

False nature said there came absolution with the gift of just one glance. Common sense told me that as reality shifted in dreams, so too did the honesty given truth.

I could rely on neither, I just wanted to touch her. I wanted to be close enough to breathe her in. Like the sweat and smell pushed from her pores was a greater intoxicant than the oxygen my lungs fought for. I wanted to put my mouth on hers and leave it moist. To touch her skin, to feel her hair, to put physical textures to all the things I saw as I looked at her.

Her smiled suggested an invitation. A greater sense reasoned that a hungry smile offered to prey would look much the same. Where was the line between a desire to welcome, and the need to disassemble those before her.

How well did she balance this line. Was she the demigoddess left to rot alone in the temple built for her? Or was this nothing more then a shrine to another unseen and dead force, and she the useless thing left to guard the entrance.

Perhaps it did not matter. Or perhaps I had finally found a riddle that would cause me a desire to see it through to the end. Where my hands would fall over her form and twist it into some sort of position that offered me an answer. Would she lie on her back and confess to me the nature of living death? Or would she lay speechless and spread her legs to let spill out the seeds spit from the mouths of gods? Would she tell me what fruit would grow from such a seed?

I could spend a lifetime there, silently answering my own questions, never once addressing them to her. I wanted to speak, but she wore such a weary look of futility across her features. Like every question would simply be answered with another question. Like every moment that passed was just another reminder of how she had found her way to that spot.

And I thought...

For all the beauty I saw in her sitting there, was there a force or reason in nature that would cause me to want to take her place? To be held fast to this dusty corner which smelled like used time and dead clocks. Would I want to know the sweetness in her smell was from the drying of her blood beneath the skin, or the vanilla air congealing on her body. Would I really want the answers if she had the mouth to voice them.

Curiosity suggested yes. A deep-rooted knowledge of myself answered by pushing my feet to move. I turned away from her and wondered briefly if I looked back quick enough if I could catch the illusion broken. But I didn't do this. Whether she cracked and faded away from my eyes, I could offer her painless immortality by keeping the memory of her as it was. Something dead and beautiful. Something silently screaming for release.

I left her a riddle.

-excerpt from "La Femme Mirabella" inspired by the photograph "fruit of the Secret God"

Fruit of the Secret God

—— the dark erotic images of John Santerineross ——

Reality creeps away.
I am hallucinating
to the beat of your footsteps.

"Johnny got a cross"

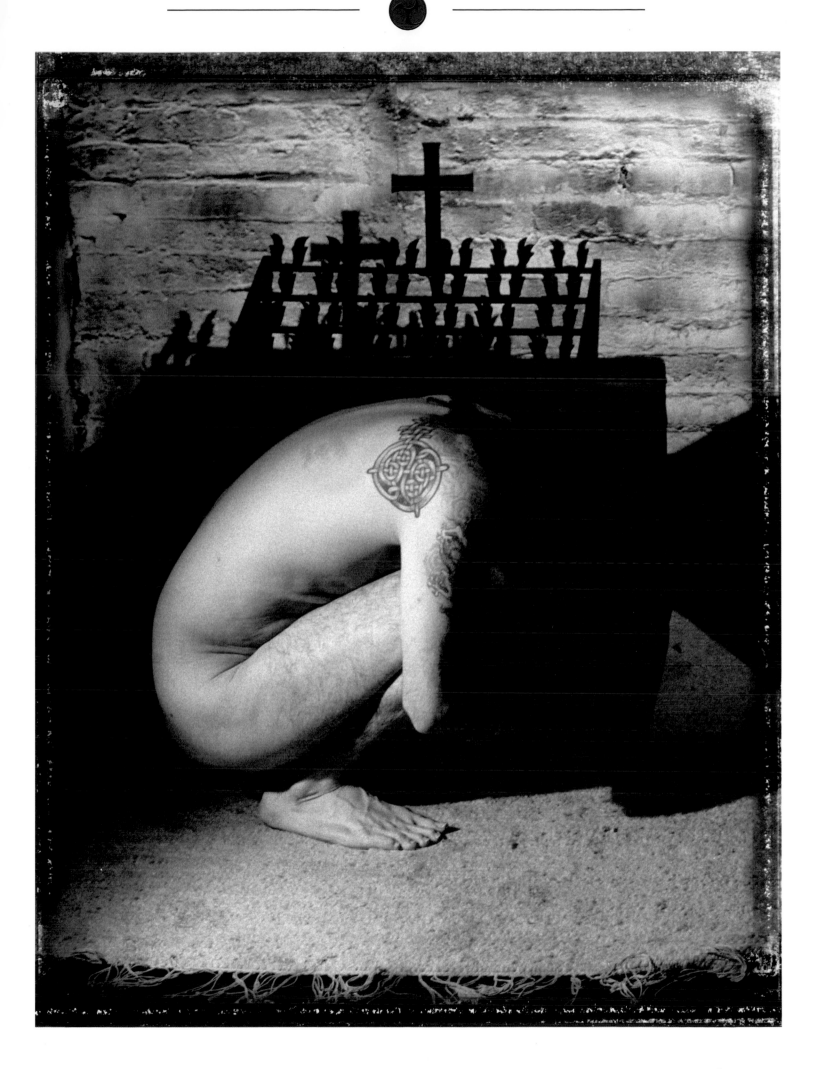

My eyes stopped looking
and the words came to me.
They unfolded out of boxes
and danced in circles.

"feast of the relics II"

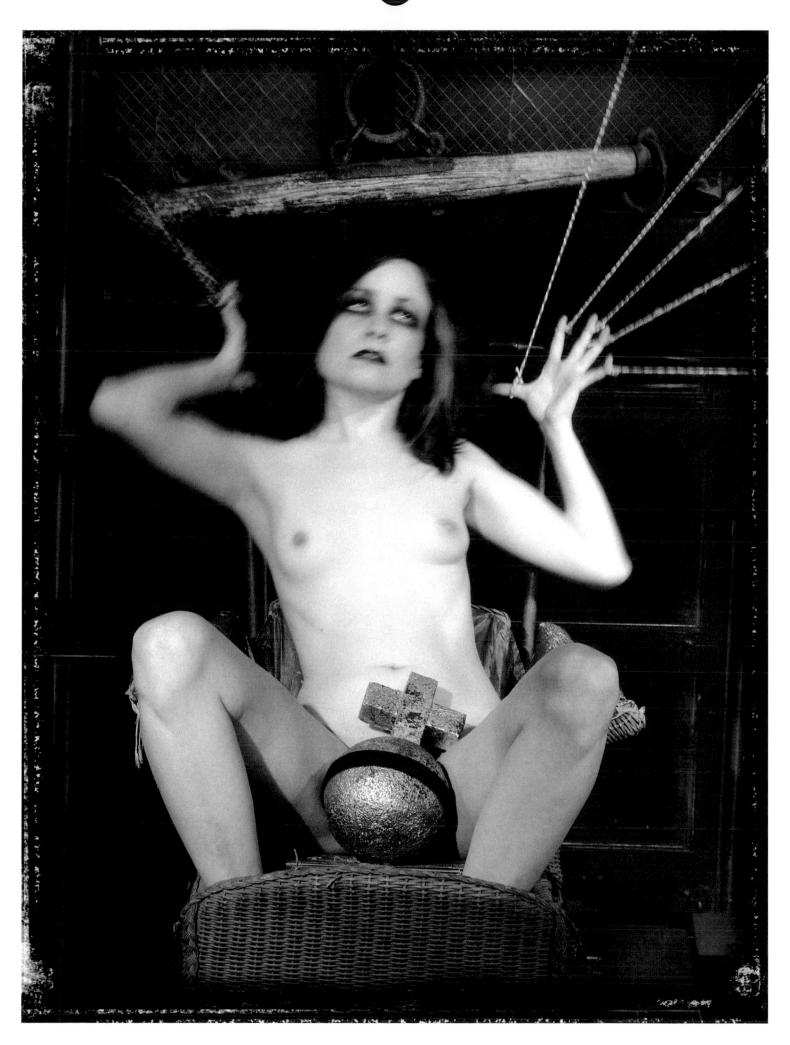

And this piece was cut
from a blessed virgin.
While this piece was cut
from a wretched whore.

" the holy watcher"

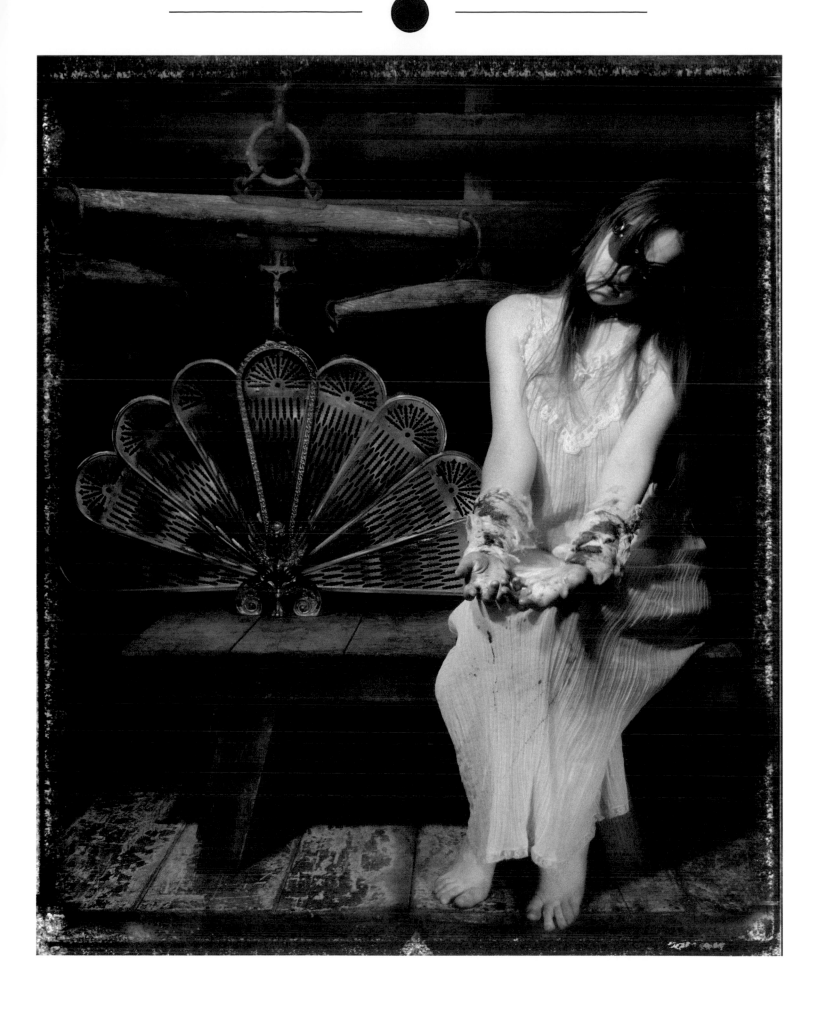

There are tears for everything
and you've seen them all.
Wet smears on brittle skin
are more comforting
than words.

" the annunciation"

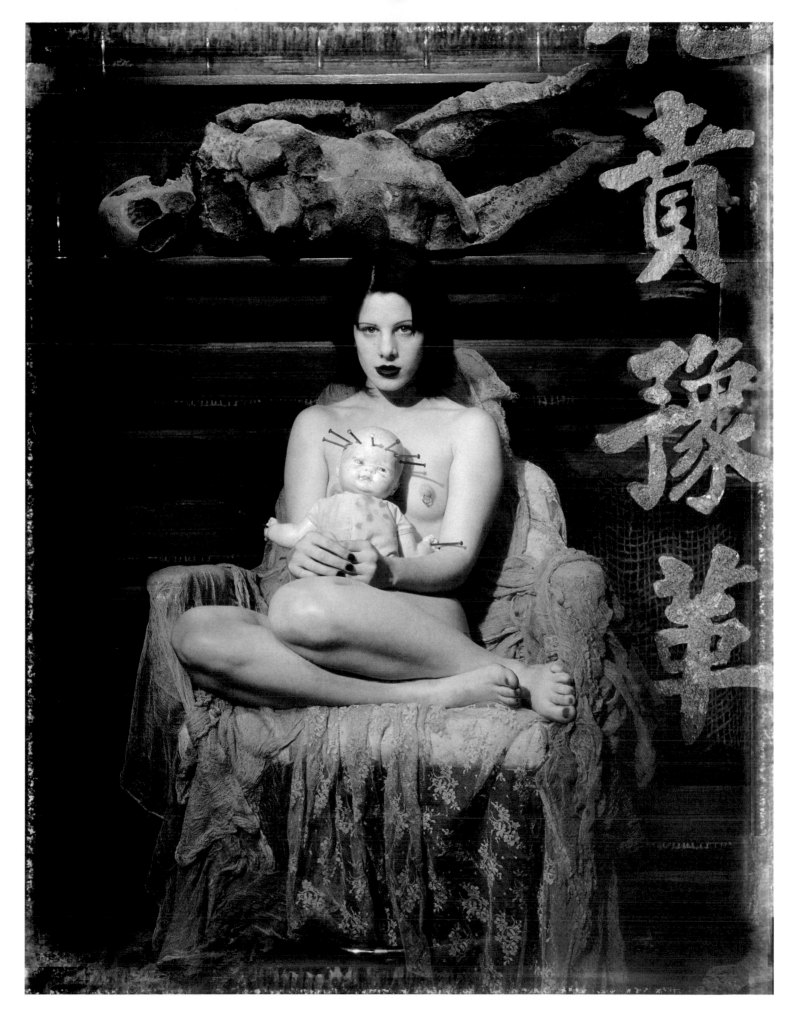

Fast and full,
I am spiraling
through an unrelenting
wind tunnel.

"Iris attending to the gods"

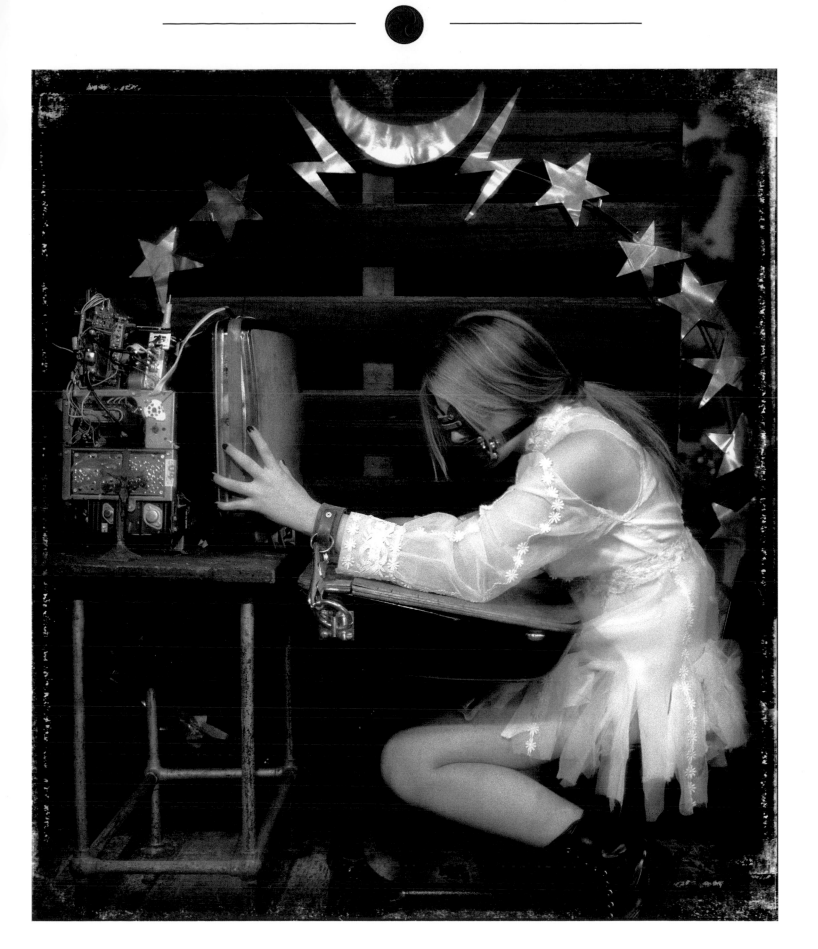

Floating on your moist vital fluids,
my voice echoes in a dark cavity.
I am singing my praises.

"the seduction of Aphaea"

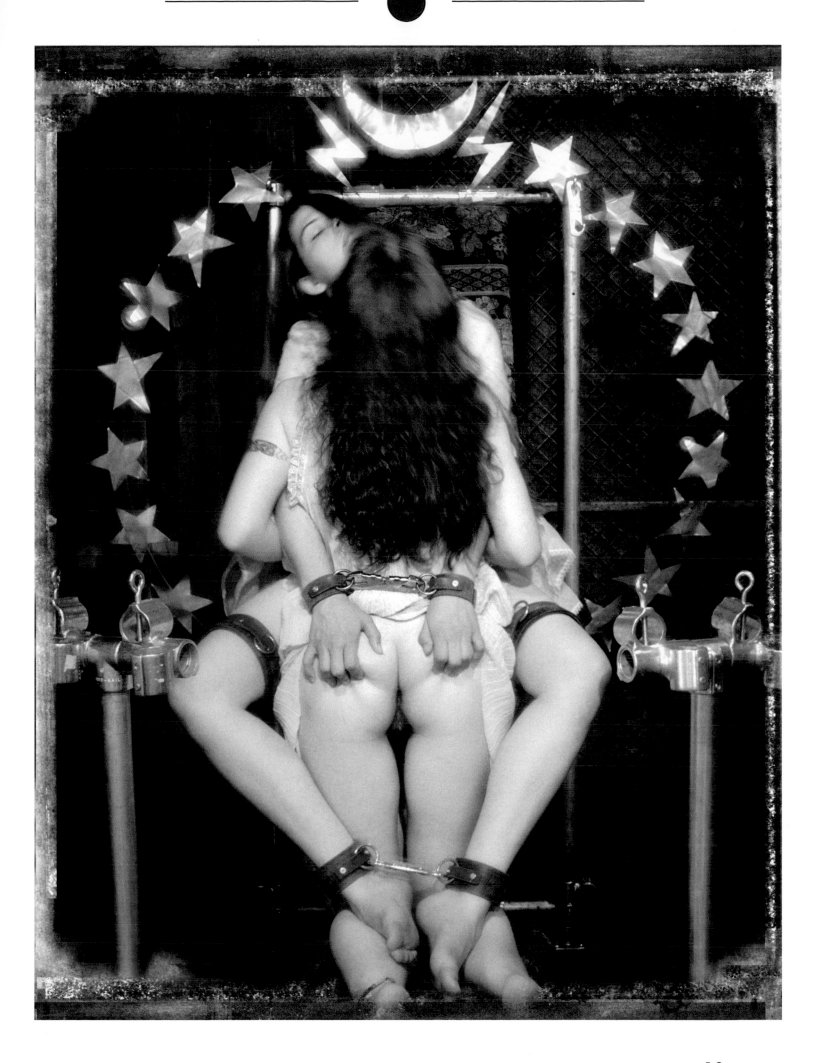

Ice hung
from the heavy branches
outside my window
and from each word
you dropped at my feet.
For seconds
we thought it was over.

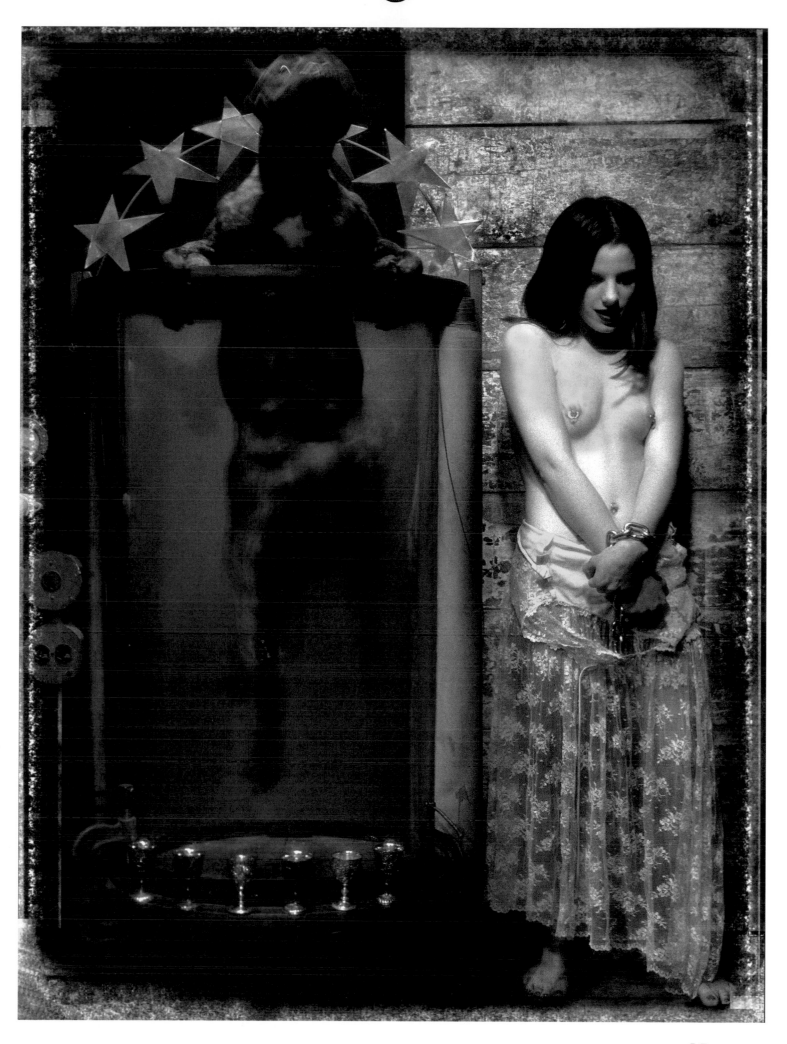

The sun strikes ice crystals-
blinding.
Since you left,
I've had dreams
about stealing things.

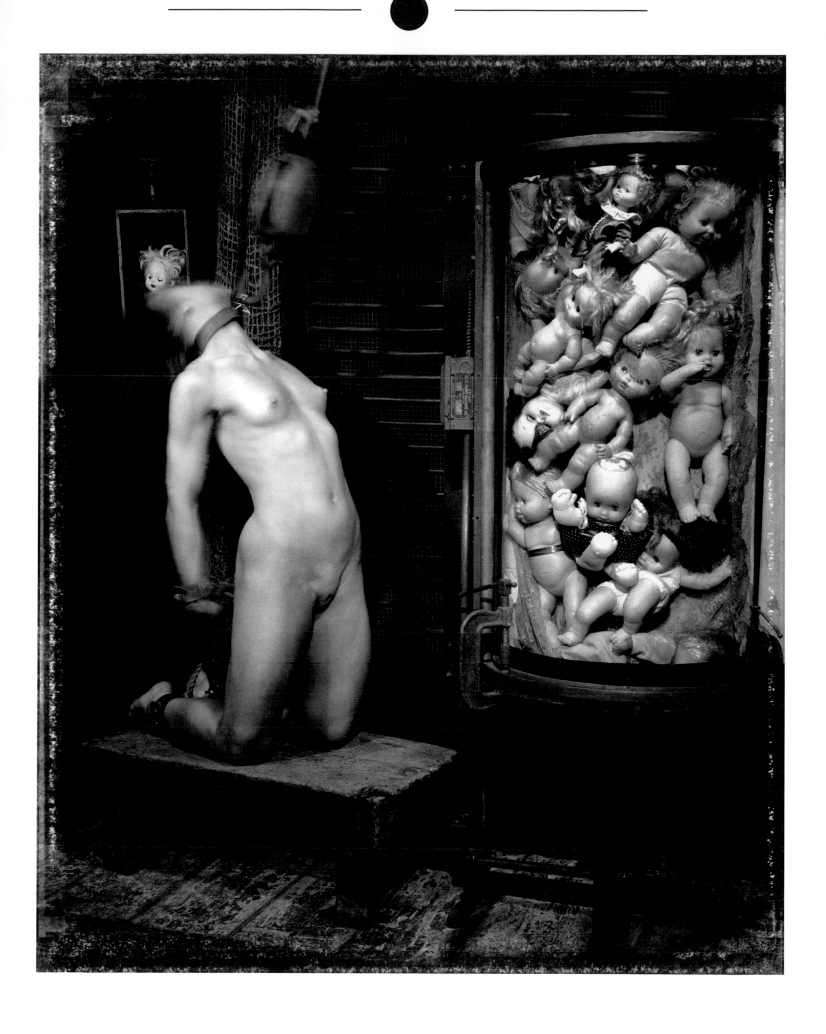

This mirror is multidimensional.
A series of coincidences
bind our souls.

"ransom of the fate"

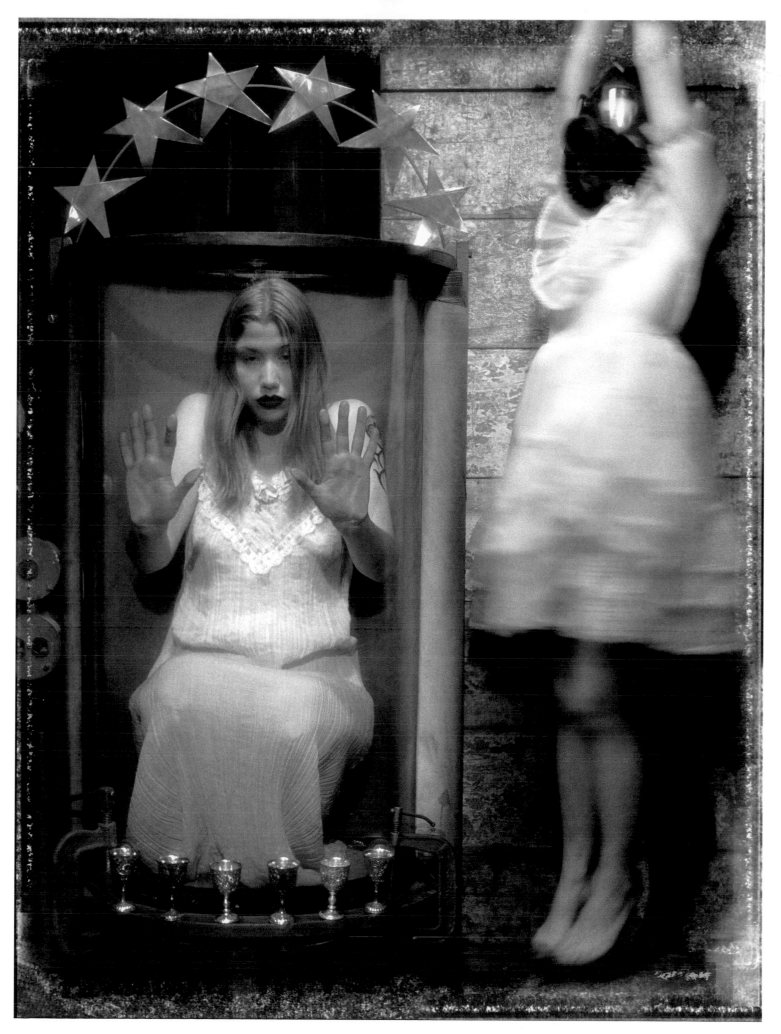

The wetness of kissing
has been rare.
The warmth of sweating
has been forgotten.

"the invention of god"

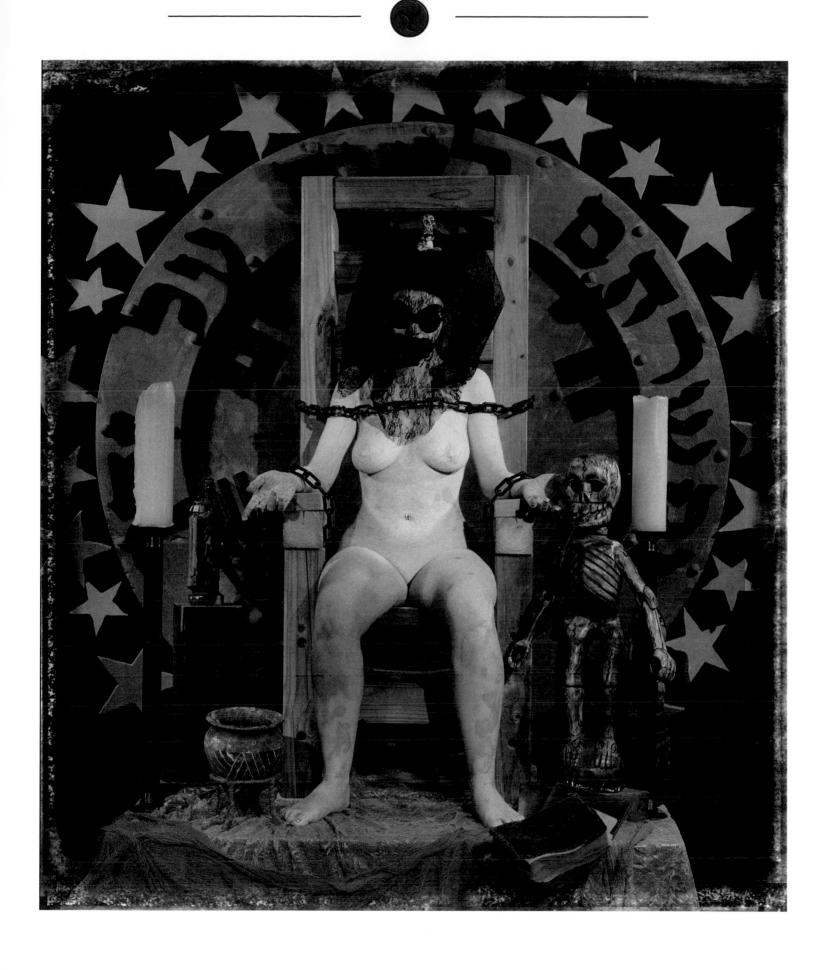

A violent descent;
the wreckage lands
in the poisoned room.

"the sacristan"

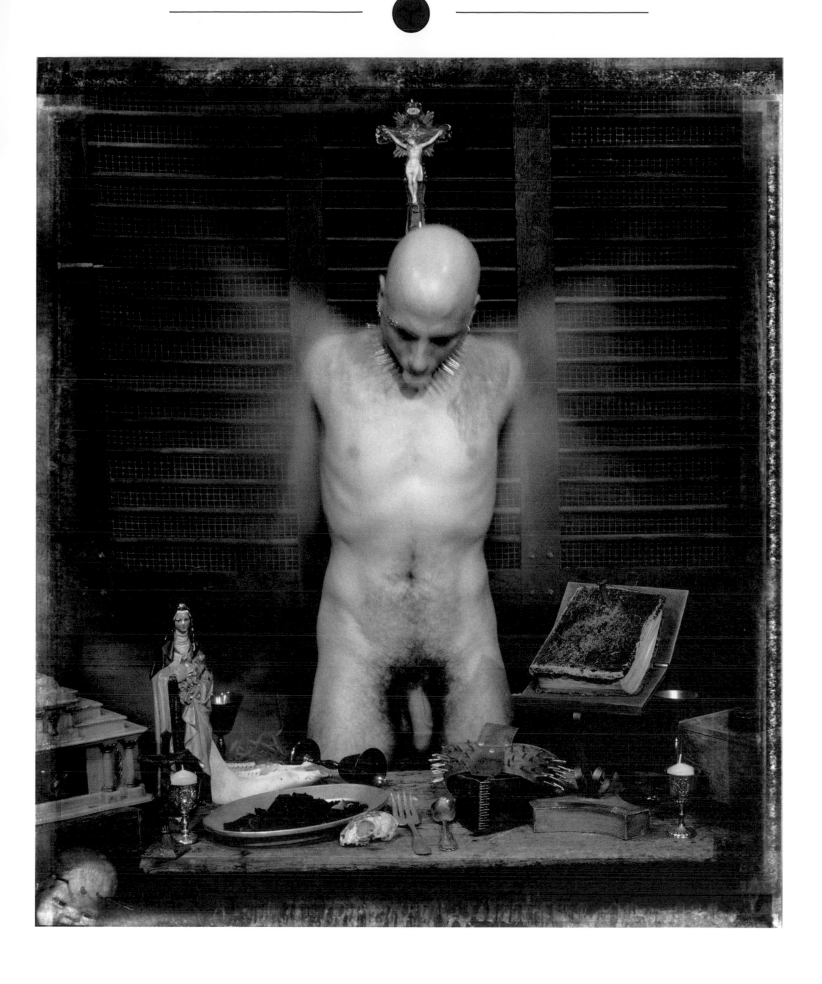

Nothing masked
such agile rotting.
I grew sick
from the incorrigible smell.
Then the scalping was arranged.

"the seal of the seven"

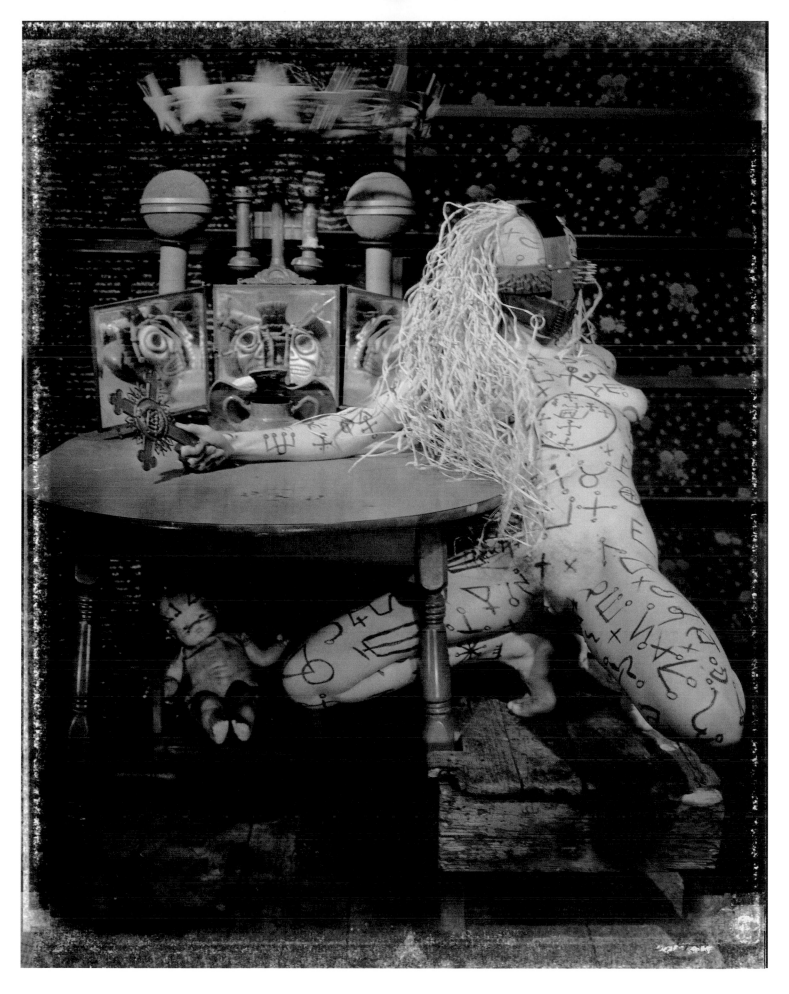

Innocence finds its way
into the eyes of children
like age devours
all hope of redemption.

" prisoners of our childhood"

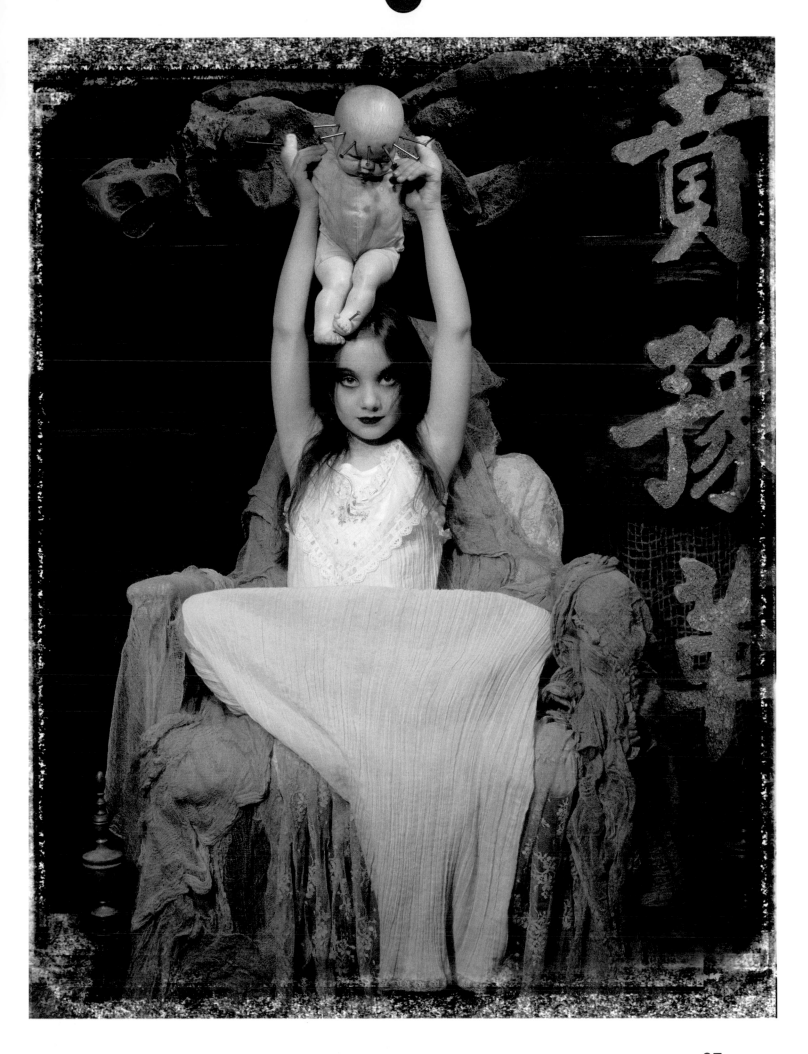

We are at the beginning.
You come to me in fragments.
As inhibitions evaporate
we are same.

"we who are not like others"

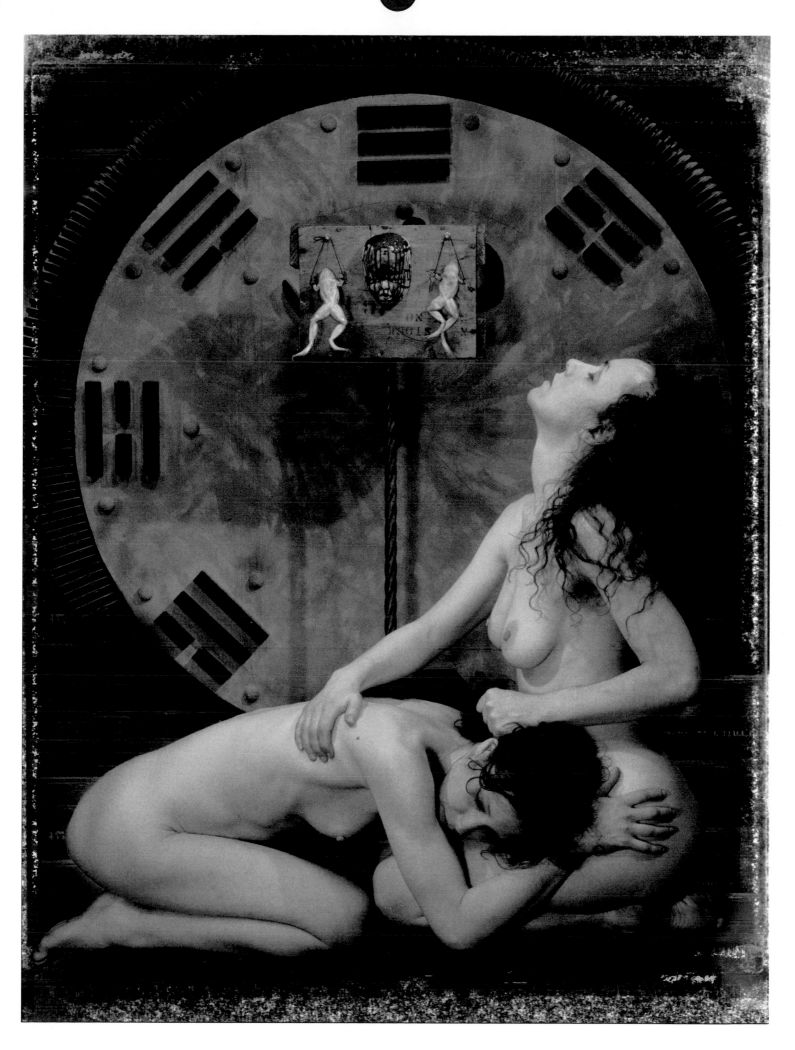

It was the pulsing
of your veins
which let me to move so freely
underneath you.

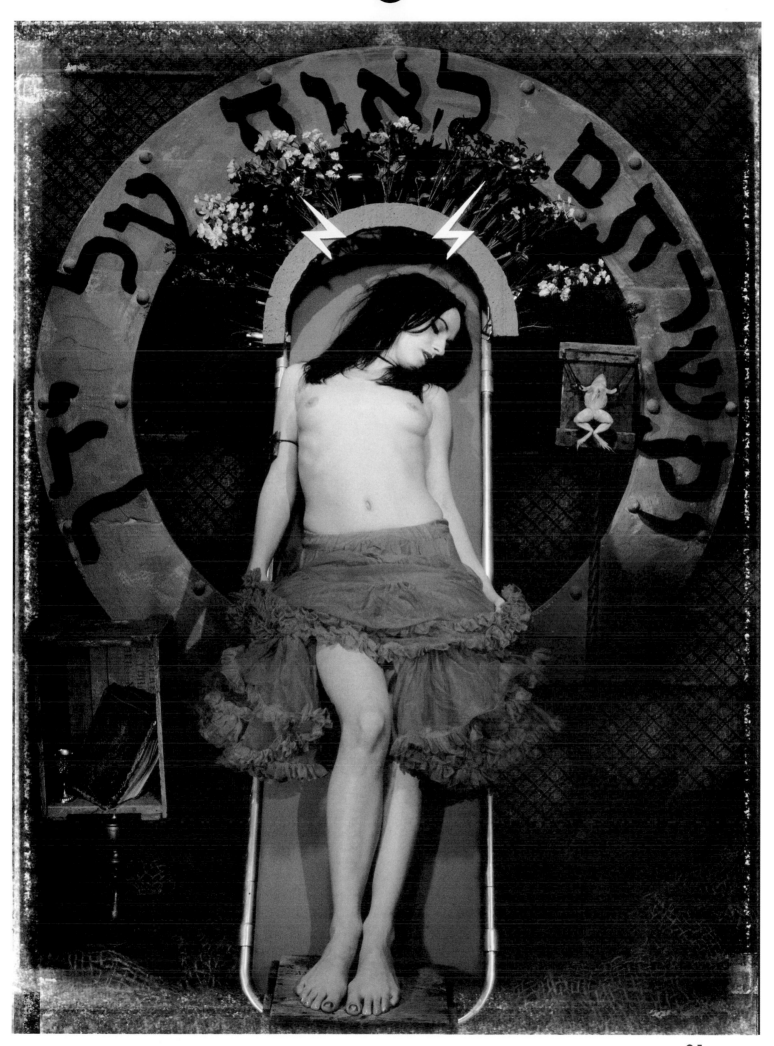

In an icy spray of light,
I feel for your pieces
disconnected and raw.

"the corn doll"

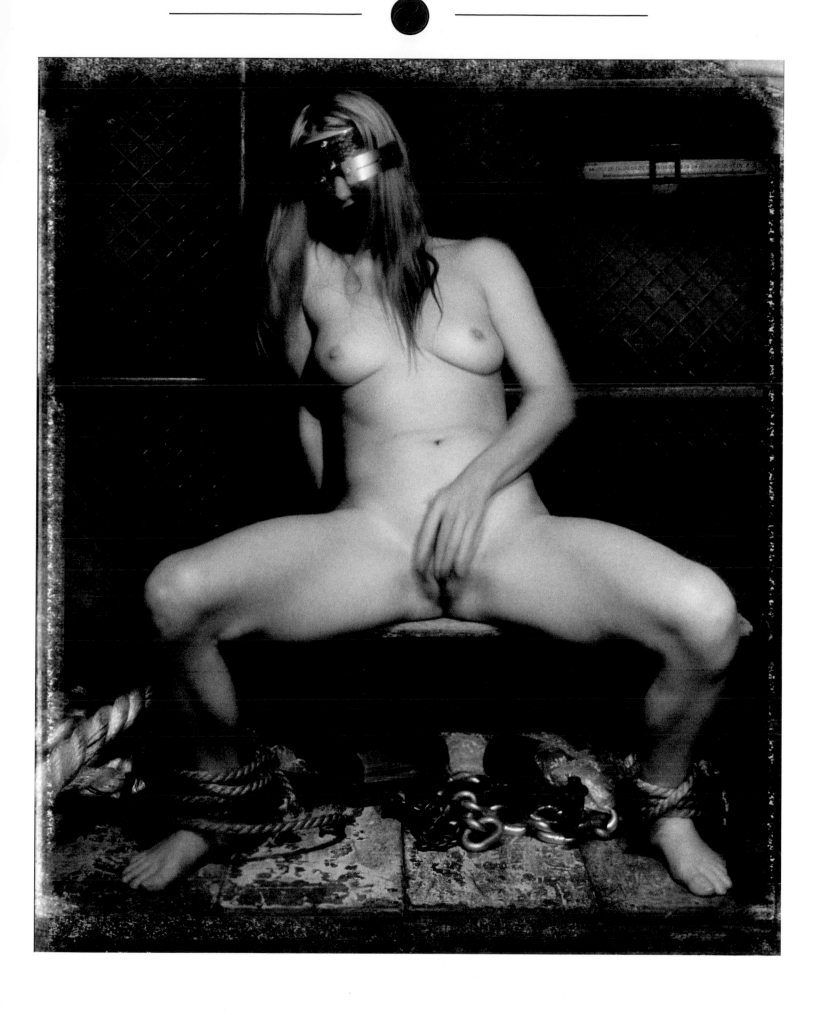

Blind and unaware
of impending dangers,
burned by the intensity
of the moon,
lost salvation is quivering
above the dry brown soil.

"attis driven to insanity"

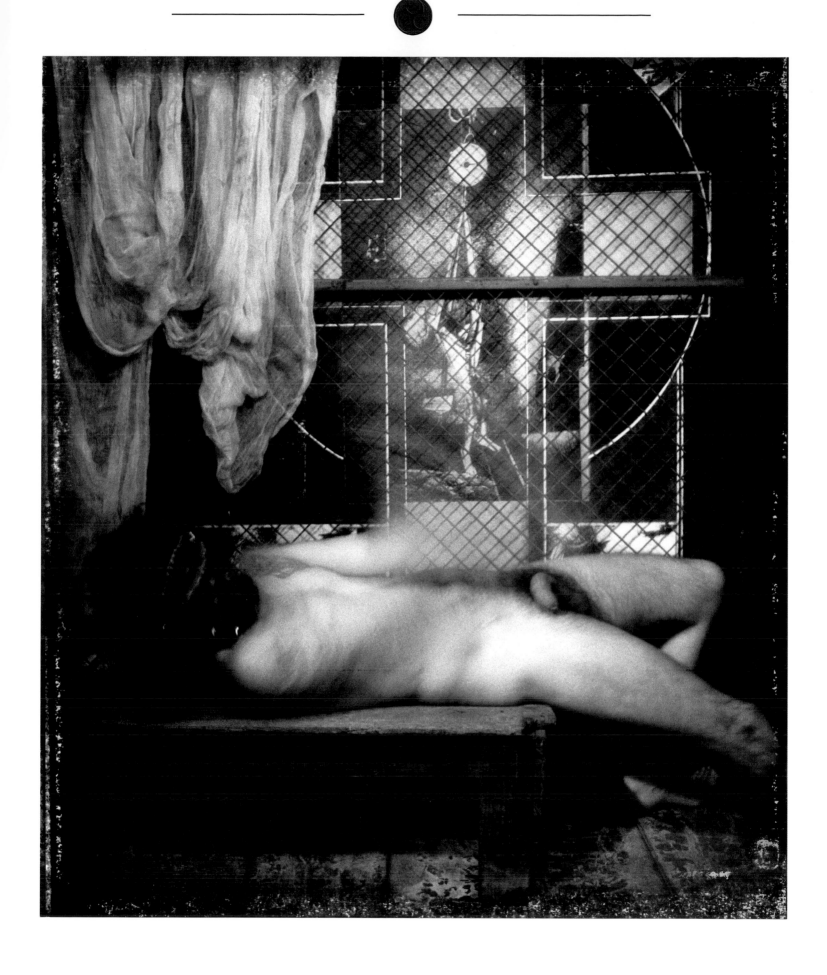

Old rust fell away
leaving sores and resentment
while I remained waiting
for a wind stronger than you.

"Arce deprived of her wings"

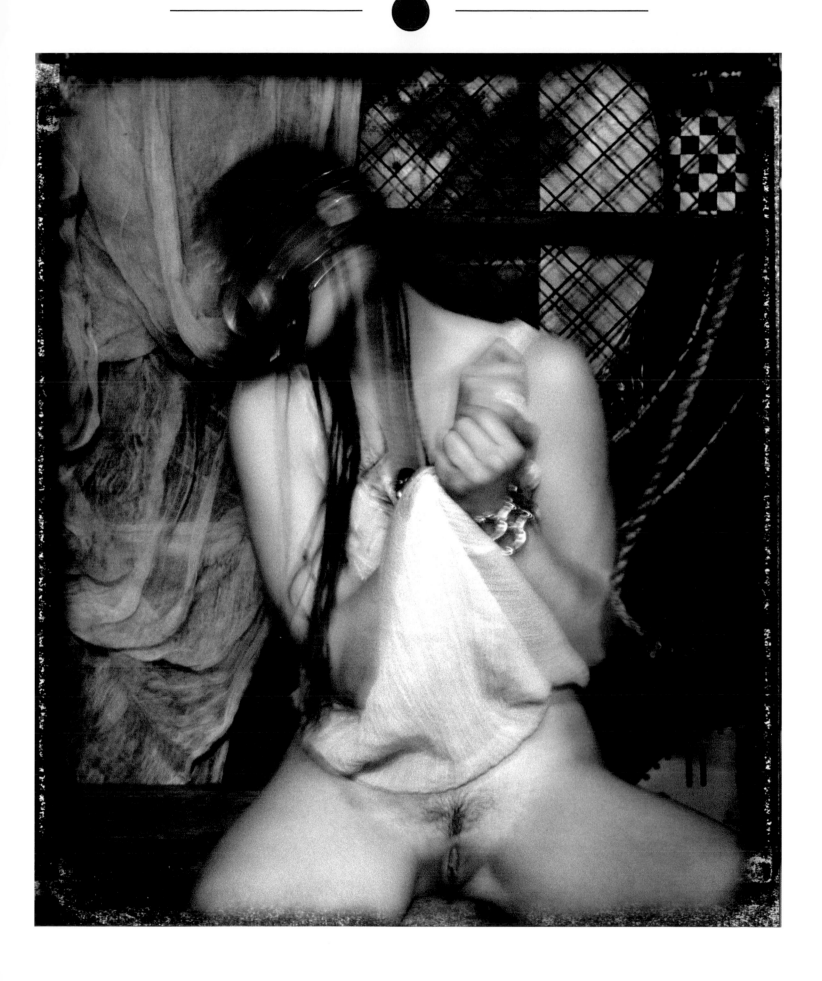

We bury the mirrors
of our caretakers
and we accept
the reprimand
of broken glass.

"alternative meat"

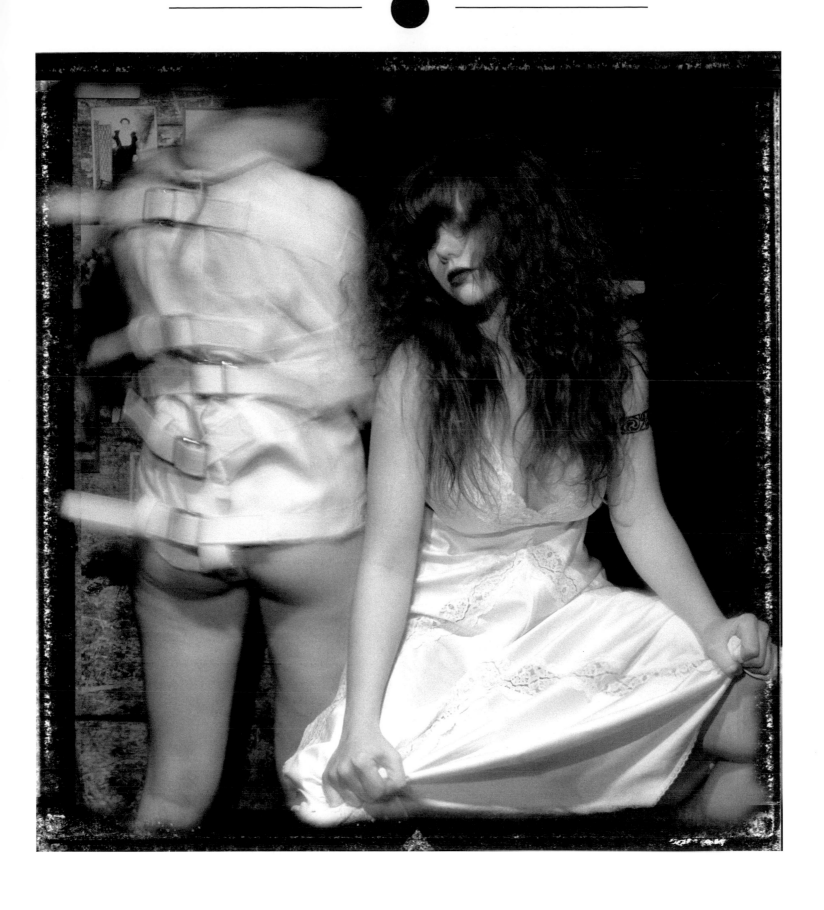

*Quick ignitions
become dangerous fires
which eventually die
in smoldering ashes.*

"corn muffin man"

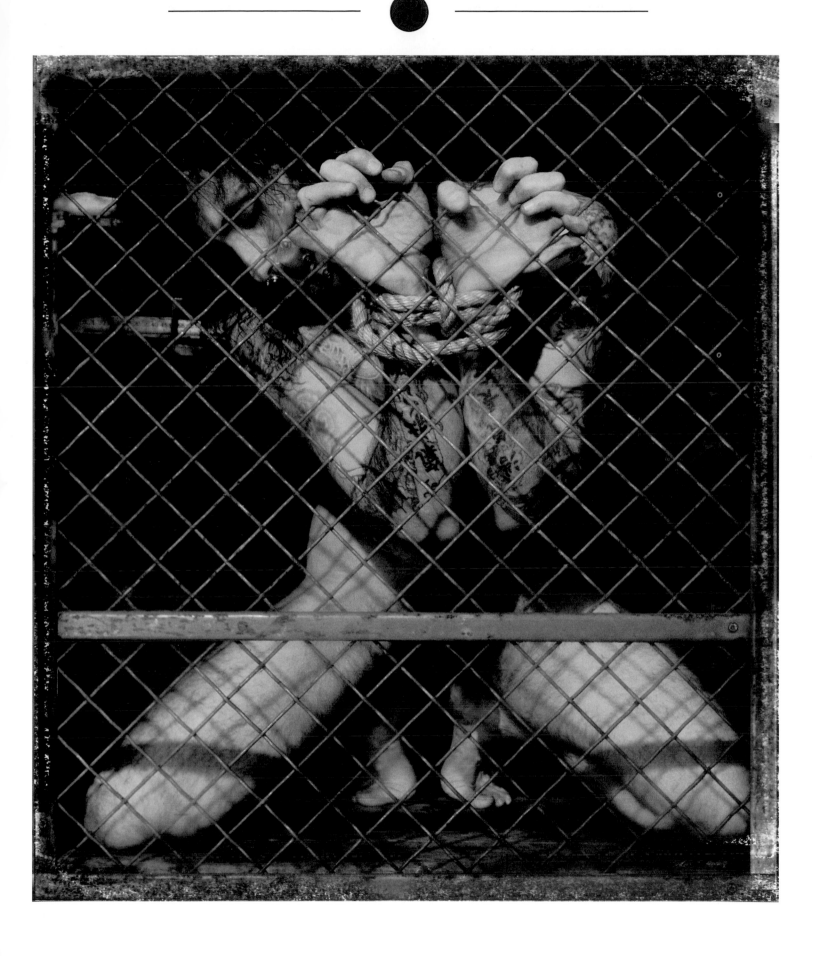

No hesitation trails from caresses
when watery mouths
are demanding submission.

"pursuing the white stain"

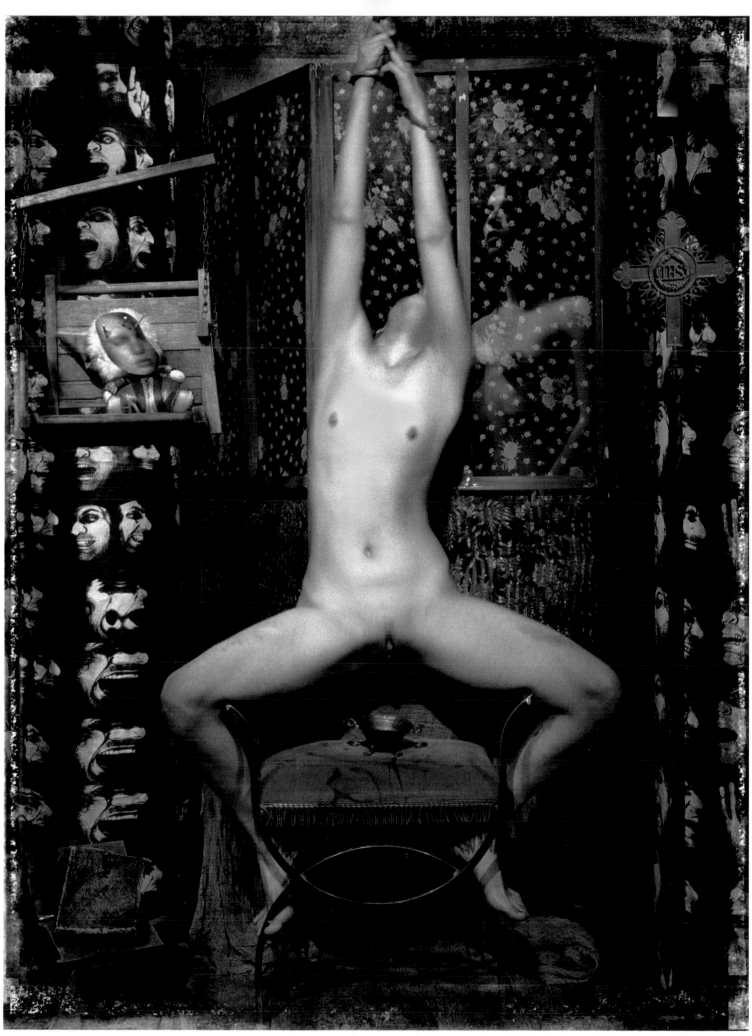

Virtue by luminance
is born from the loins
of just one glowing light.

"Raziel learning to write"

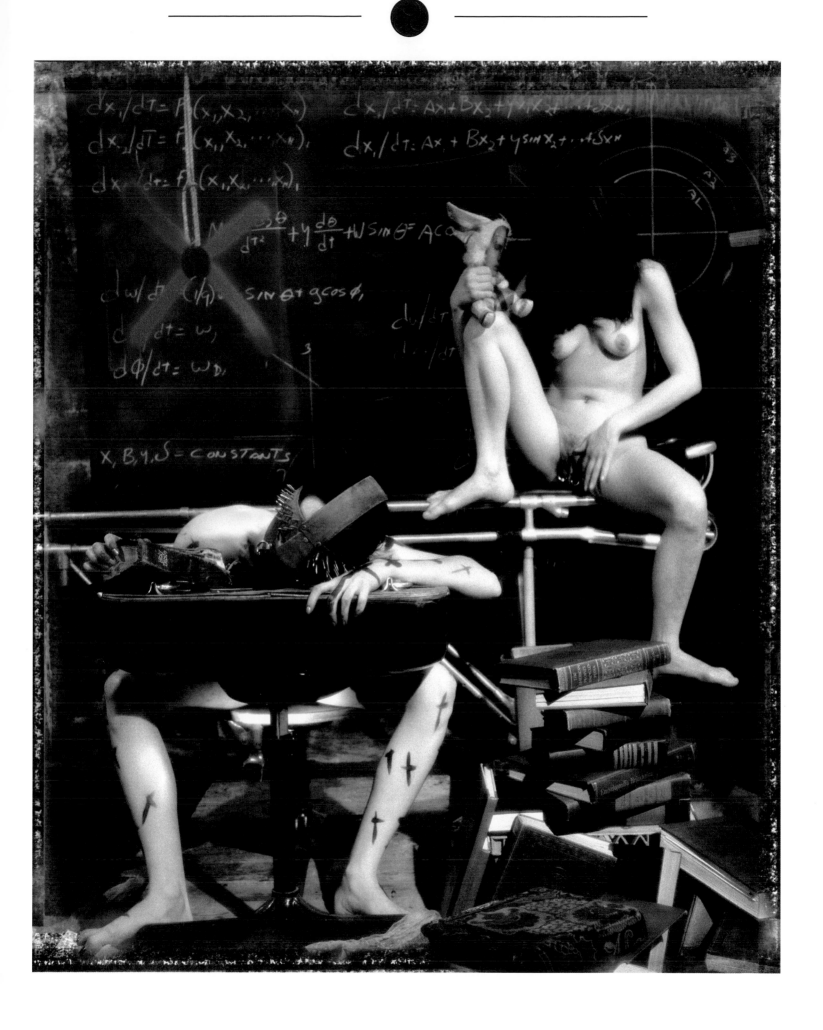

Desire invited me
to give reverence to intimacy
and fear turned to pleasure
as rapture encircled me.

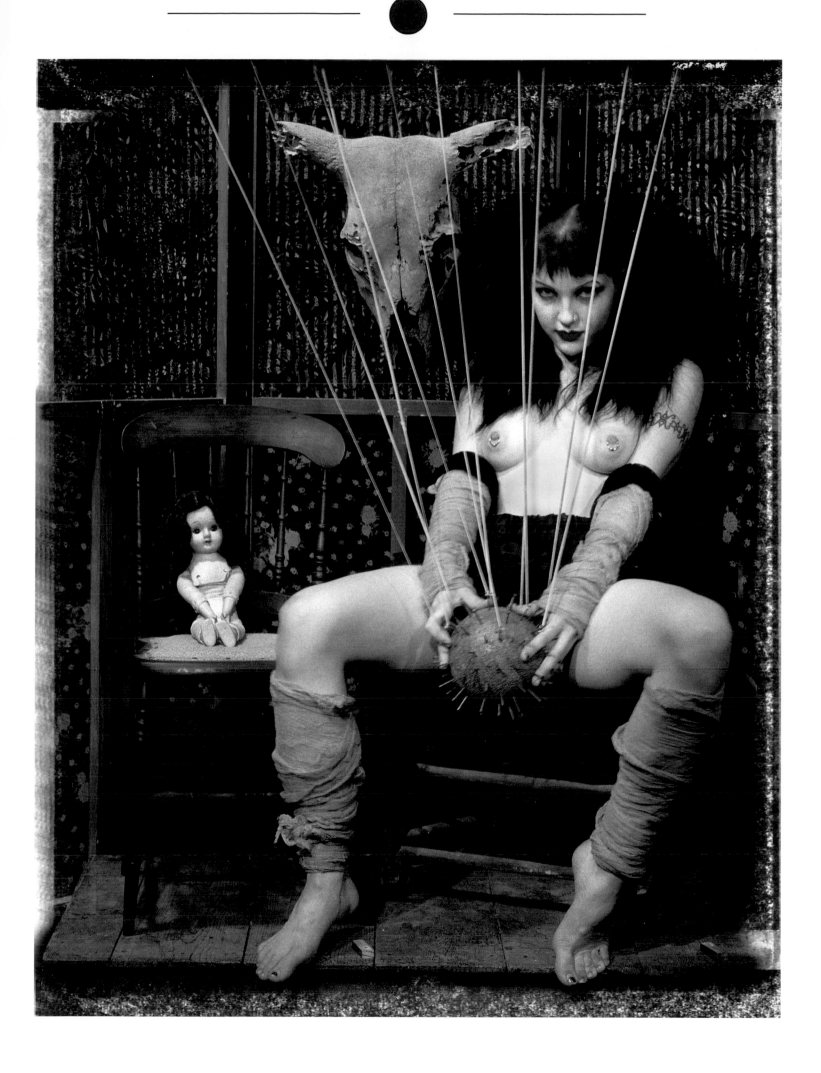

The moon whispers solace
and hides pale skin
in shadowed places.

"the subjugation of Gaia"

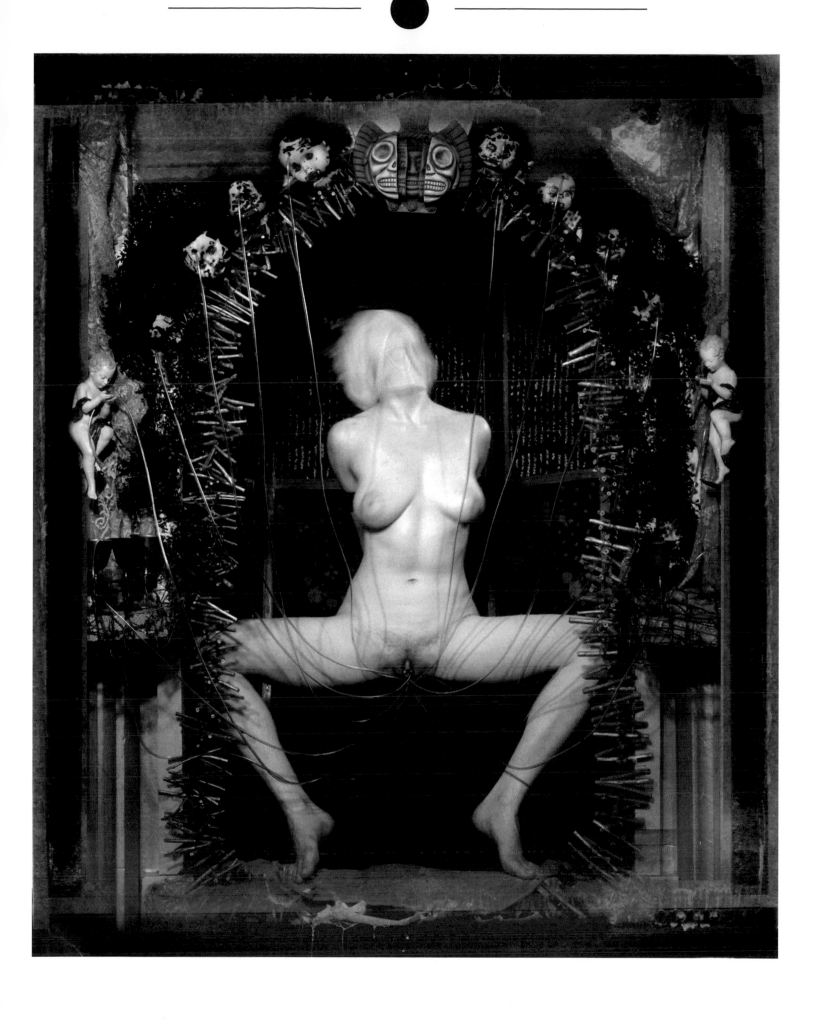

*Entrusting faith
threatened to be
the most terrible
mistake.*

"the water margin"

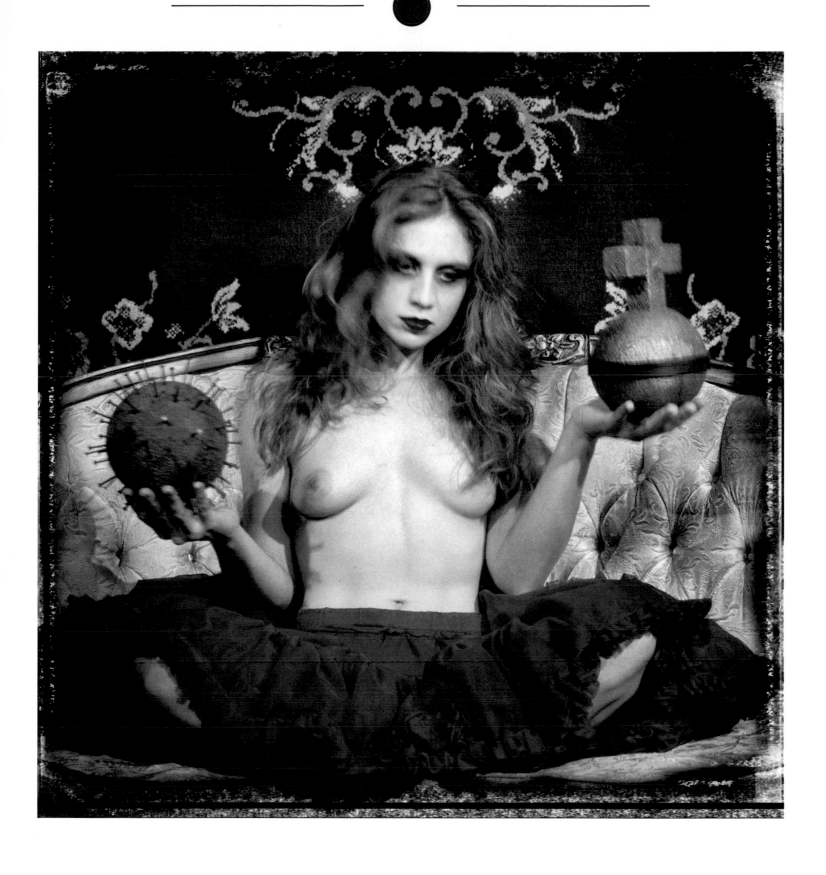

*Blistering unattended wounds
cease their merciful crying.
Blistering unattended wounds
are silenced by weary futility.*

" feast of the relics"

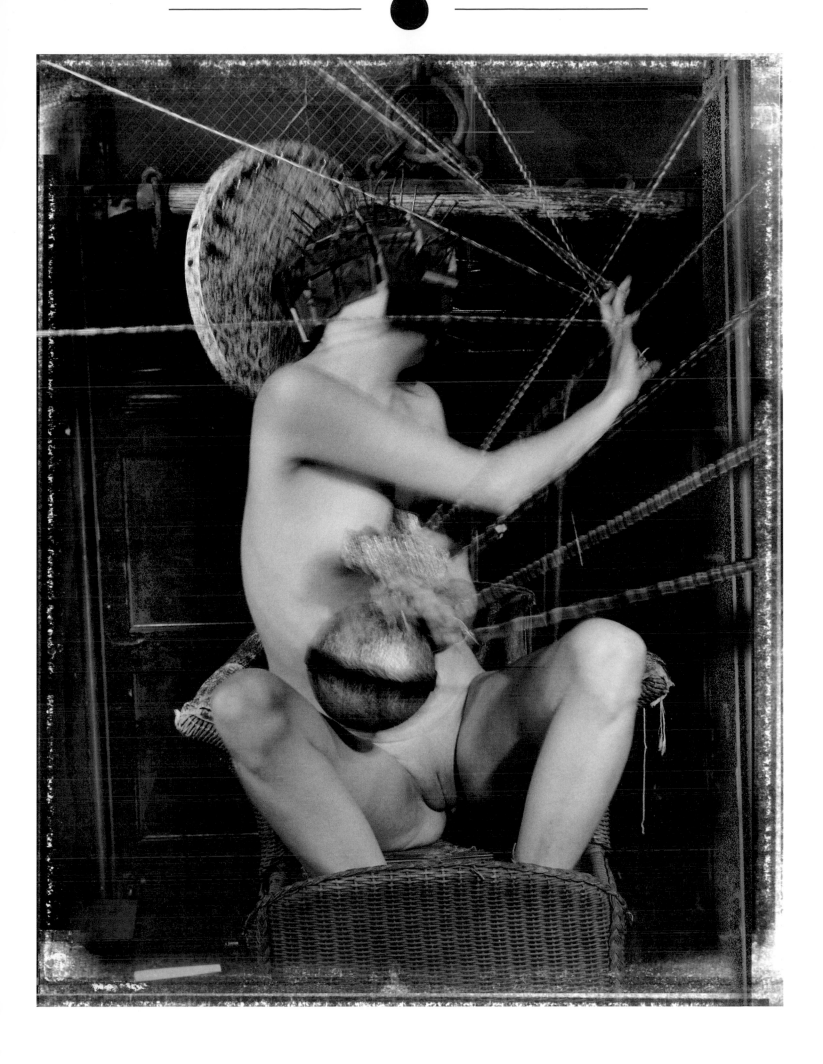

Enchanting monsters
awaken sleeping desires.
Passively, they are releasing us.

"words that have no human sound"

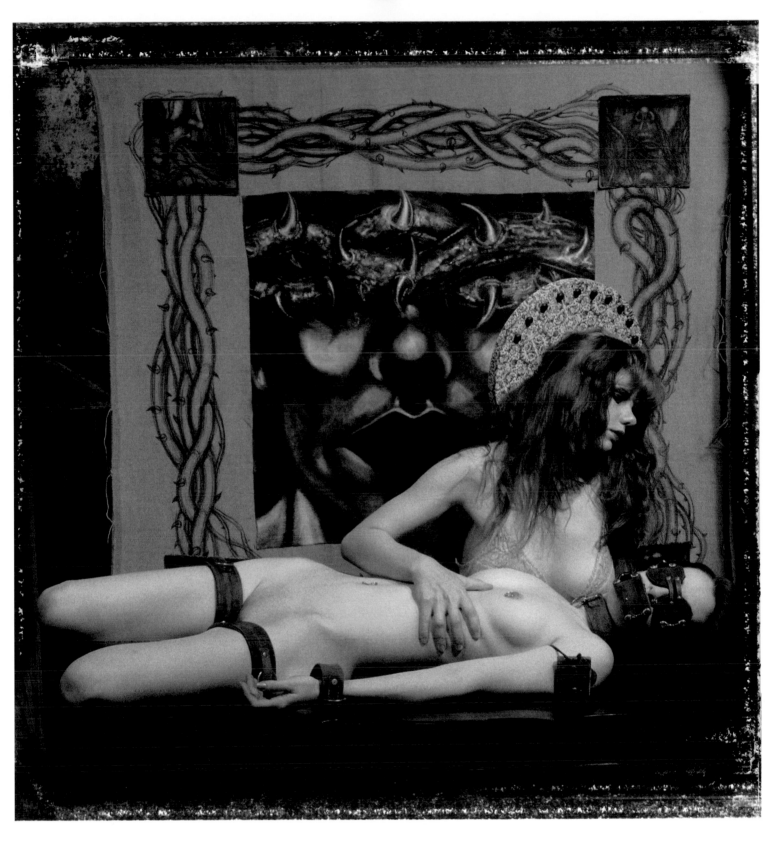

Each time I feel
the cool caress of metal
I hear you screaming quietly,
muted as if
through a padded tunnel,
numbing my exterior.

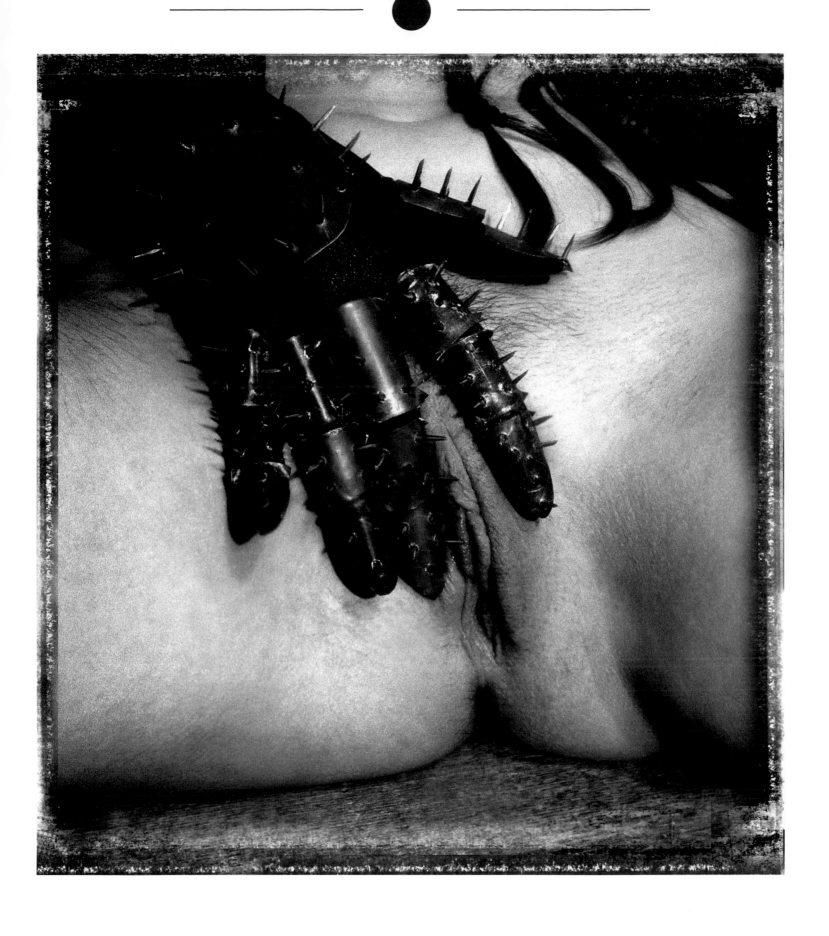

He coasts through melodies-
layers of cotton noise,
weaving indiscriminately,
ingesting scraps of pollen.

"Israfel looking into hell"

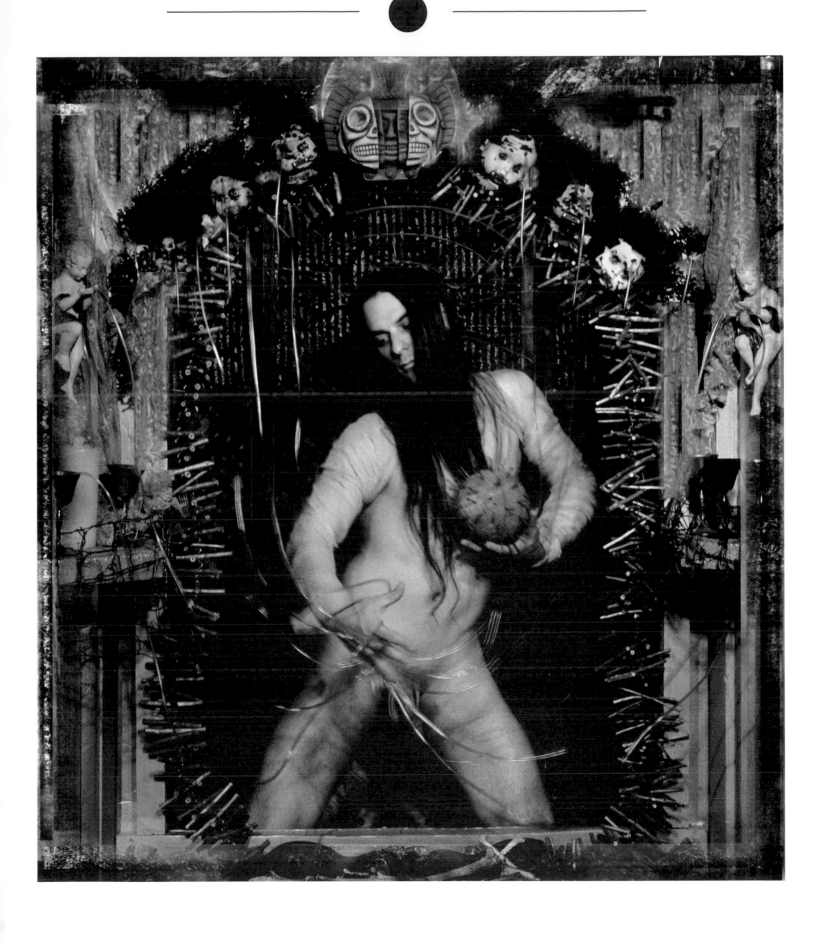

Like rocks that feather
to the bottoms of oceans,
something inside me
lays omniscient
and still.

"conjuration of the mystery"

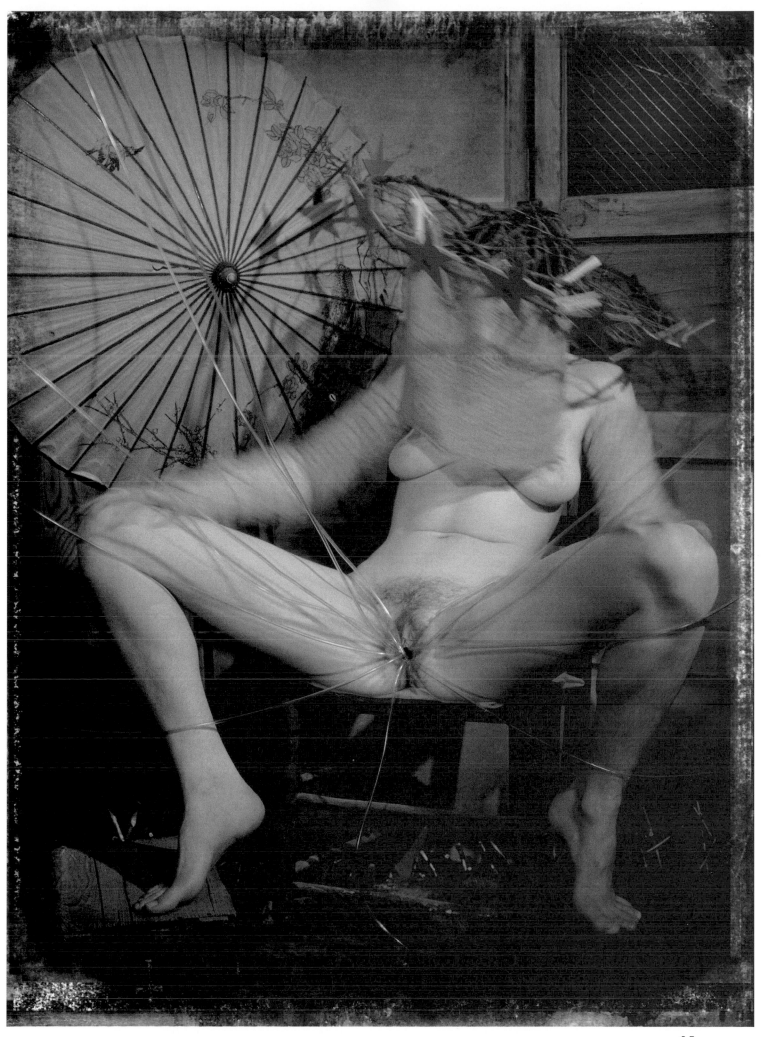

The first time I saw her
she told me she knew a secret
about a secret.
The next time I saw her
she had wings.

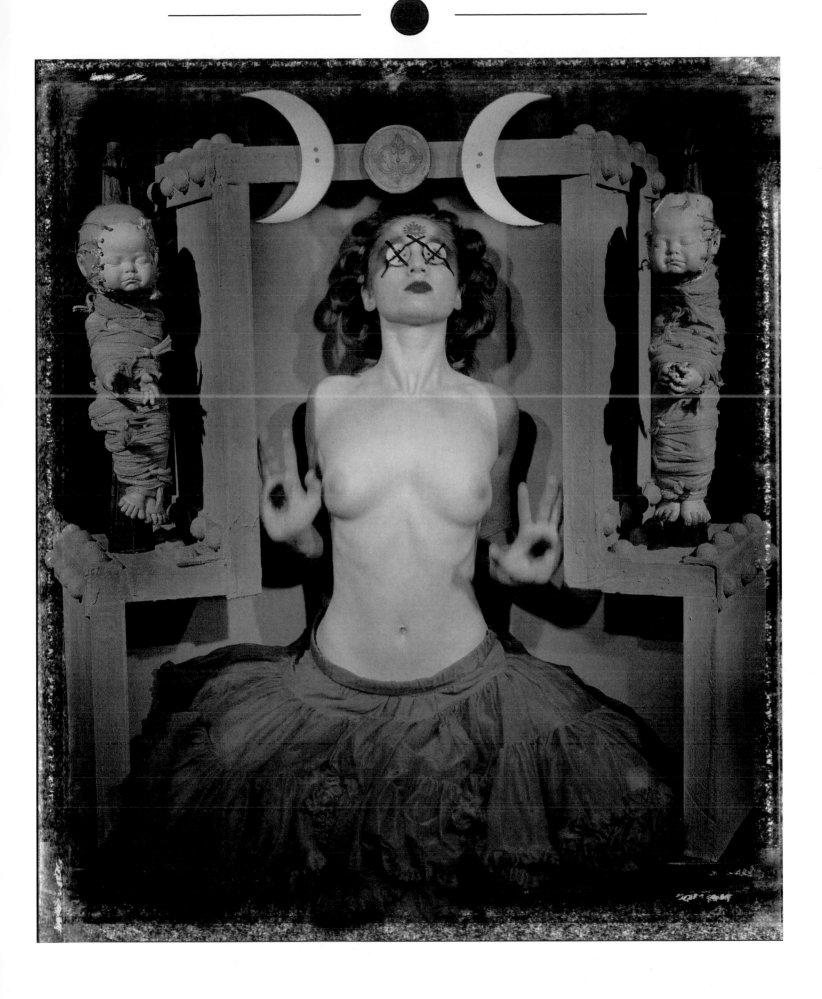

Philip Miller

Internal perspectives

One cannot absorb the beauty of a Santerineross piece at a glance, as captivating as that one glance may be. One doesn't purchase a Santerineross to balance the decor of a room, though once hung, the piece may cause you to linger in that room more than in any other. This art ensnares you through a sensual image, then immerses you in a visceral waltz of imagery, both real and fantastic. Half of the emotions and experiences you will encounter are part of the art; the other half will come from inside you. John Santerineross has a rare talent, weaving complex compositions that unravel like good mystery novels, engaging a viewer's involuntary instinct to see how things are going to turn out.

Born In the Bronx , New York, John was an only child raised by his mother. He was a high school track prodigy, but torn ligaments in his leg forced him out of the sport. To replace his love of competitive running, John discovered his artistic ability. The diversion of his focus to art was propitious, earning him a full scholarship to Rutgers University. He completed his education with an M.A. from New Jersey City University.

For ten years, John plied his skills as a ceramist to create decorative abstractions, which now hang in many prestigious corporate headquarters. When the medium of clay imposed the restriction of size that John wasn't happy with, he turned to painting, incorporating photographs cut from magazines and newspapers. After two years, he grew tired of using other people's images and began creating his own with the camera. The work you see in this book is a modest reflection of his success in the last seven years, centering on the photographic image.

John has a lot to say and he takes advantage of every available opportunity for elaboration. The compositions in his photography utilize narrative

imagery, blending symbolism of ancient and modern cultures, sharply con-trasting textures, dramatic light, and the title of the piece.

Though some have labeled him a "fetish" photographer, John does not consider himself a fetish artist, and an honest appraisal sustains this claim. The bondage and fetish elements are not central, but rather integral components of greater, more universal messages. Bondage, vulnerability, and confine-ment are metaphoric tools perhaps suggestive of the fragility of humanity in its environment. The protagonists in his visual tales pose among rough-hewn wooden walls, dilapidated machinery, the chassis of broken electronics, wire mesh cages, and battered furniture. Other props include wine chalices, cru-cifixes, rainbows of stars, crescent moons, and lightning bolts, all tokens of the symbolism of the ancient mythology referred to in the works. His lighting is dark, dramatic, foreboding.

In contrast with his ceramic abstracts which grace the walls of prestigious homes and corporate headquarters, his sexually, spiritually-themed images are receiving a cooler reception from the gallery owners who were once only too happy to hawk his previous, less polemic work. The gallery owners fear the images may be too stark for the patrons' delicate palate, underestimating their capacity to appreciate honest humanism. To be commercially accept-able, images containing religious symbolism, nudity, and sexuality must adhere to the rules of plausible deniability. Though we may feel distrust, doubt, or even scorn for religion, religious iconography in art may only be portrayed as exalt-ed and virtuous. Nudes may be sensual, but must be essentially chaste forms, appreciated only for purity of line and the interplay of light and shadow. All the lust in our hearts must be denied or at least merely alluded to, and even then never vividly. It isn't the presence of sexuality and religion in his work that frightens them, it is the way they are presented. Women in his work are pre-sented without apology for their bodies or for their sexuality. His poses are often graphic, but not exploitative. Just as the vagina is given no more emphasis in the composition than any other part of the body, it is neither shyly

hidden by drapery or demurely concealed through clever posing or discrete camera angles. If eroticism is intended as part of a piece (John's work is rarely of a singular theme), it is achieved through many elements in the composition. John never sinks to pornographic display; he has far to much respect for the erotic to demean it. He handles feminine eroticism with keen sensitivity to women's experiences. She isn't portrayed as selling, or projecting, or negating. She is within her sexuality, feeling and reacting to what is going on inside her. She is a whole person, enjoying the voluptuous and wrestling with the demons it creates. I do not single out John's use of female images, intentionally excluding male images. Until recently, the only male appearing in his work was the artist himself. In these, as well as those images including women, the poses are frank and naturally powerful.

True, what John says in his work may make us uneasy. His statements turn us inward, beckoning us to candidly respond to and converse with parts of ourselves considered outside the realm of polite conversation. He is speaking to the universal yet highly personal corners of our psyches, to places where gods split the heavens to humble us. He speaks to the places inside of us where we moan and writhe and grin and giggle and scream with wide eyes. He invites us to Rorshach toward our own conclusions, to fuse our psychic input with his, to free our fantasies and join him in a waltz of expression.

Come and see where his vision takes you.

Acknowledgments

-A deep sense of appreciation to Alyson, Anna, Catherine, Denise, Gillian, Gladys, Heather, Jill, Joleen, Julianne, June, Kery, Lisa Marie, Lisa P, Melissa, Myke, Tracy, and Victoria, without whose form and essence I could not have realized my vision.

-To my friends, Edie, Gail, Jeff, Ron, Christin, Lily, and Leo, for their friendship and support.

-A very special thanks to Michele, who was there with me from the very beginning and never complained about or refused a single request . I will never forget your dedication or your friendship.

-To Victoria Rimerman, whose words so beautifully coexist with my images.

-To Philip Miller, I offer my sincere thanks. You are sorely missed.

-To Beth, for your friendship and support. Words can never express how I feel about you.

-and to Shaila, the corner in the triangle , the final piece to the puzzle.

Dedication

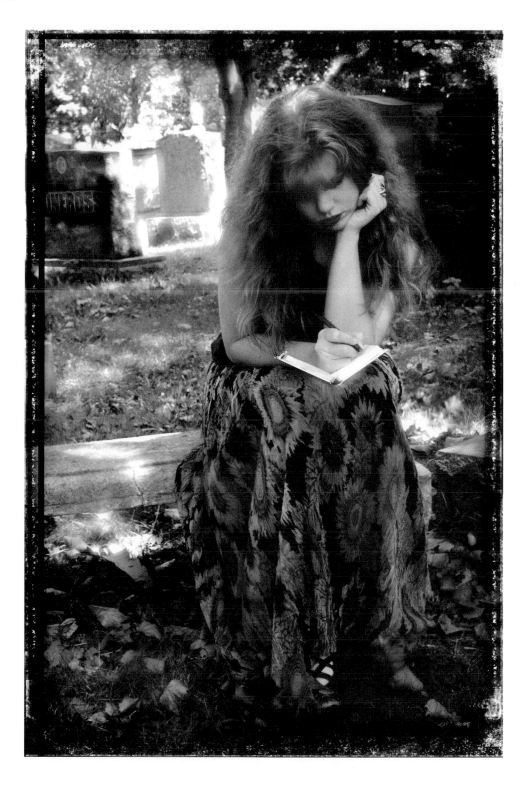

To June,
My wife, companion, and most importantly, my best friend.
".....so ancient is the desire of one another which is implanted in us.
Reuniting our original nature, making one of two, and healing the
state of man.........the pair are lost in an amazement of love and
friendship and intimacy......these are the people who pass their whole
lives together."

Plato

Colophon

This first edition of **Fruit of the Secret God** is limited to two thousand casebound copies. The photographs are copyright John Santerineross 1999. Texts are copyright Victoria Rimerman 1999, Philip Miller 1999, Bethalynne Bajema 1999. This edition is copyright Attis Publishing 1999. All rights reserved. The design is by John Santerineross. The typeface is Avant Garde book. Plates are printed in four color on matte coated stock. Printed and bound in Korea.

The records required by Section 2257 of Title 18 USC are kept by: Attis Publishing.

Limited edition 20"x 24 " prints available from the photographer through his web site or Attis Publishing. www.bajema.com/attis

ISBN 0-9673543-0-7

Attis Publishing
586 Devon Street
Kearny, New Jersey 07032 USA
201-997-3310
e-mail: attismail@aol.com